FOUND PHOTOS

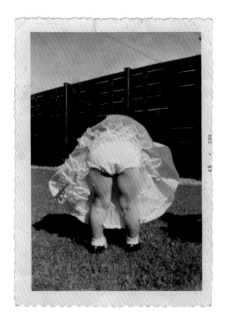

D1372757

rear ends

From the collection of **ROGER HANDY** ★ Edited by **ROGER HANDY** & **KARIN ELSENER**

ABRAMS IMAGE — NEW YORK

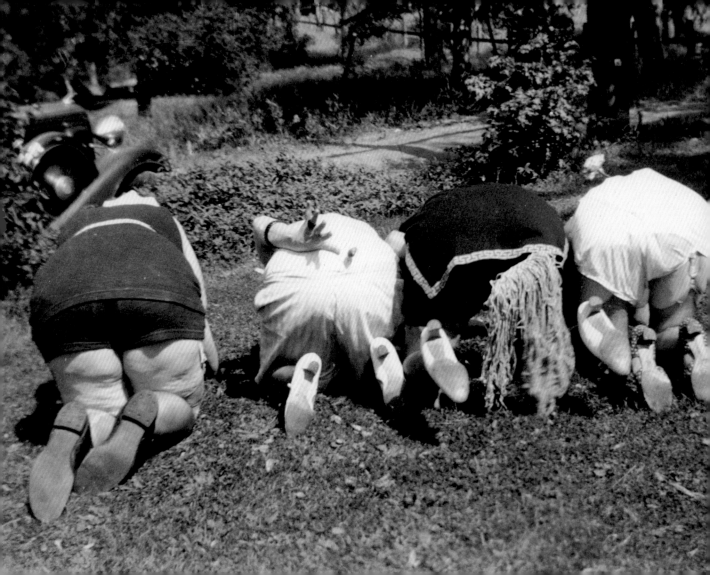

INTRODUCTION

Freud called the human posterior the "second face"—an anti-face or face without features. Perhaps that's why, on some subliminal level, the body's nether section is the source of so much humor and fascination.

A natural target for ridicule, this hapless portion of the anatomy has been exploited as an endless source of amusement throughout the ages. From the days of Aristophanes' classical Greek buffoons, to those of the silent-film era when Charlie Chaplin made an art form out of falling flat on his keister, and forward to Beavis and Butt-Head, derision of the derrière has been the stock-in-trade of generations of music-hall comedians, street mimes, cancan queens, and common jesters.

But for every instance of satire and caricature, and for every slight uttered in a burlesque house or vaudeville tent at the expense of a "prat," "pants seat," "pincushion," or "pair of buns," there can be found words of praise and acts of veneration for this selfsame dorsal extremity. The delights of hula and the Folies Bergères aside, the arse as a fit subject for artistic treatment has enjoyed centuries of consecration, and figured in as many canvases and sculptures as any facial or frontal view appearing in conventional portraiture. Aesthetic appreciation for the beauty of the backside is easily perceived in Greek and Roman statuary, Egyptian murals, and Indo-Asian bas-reliefs. The ancient Greeks referred to callipygian women—those possessed of shapely haunches. Hottentots, among others, consider elongated flanks particularly beautiful. Some tribes deliberately exaggerate and enhance the prominence of this bodily region, which they regard as an erogenous zone. A painting by the celebrated surrealist artist Salvador Dalí exhibits, propped by a crutch, a buttock as long as a city block! This same artist once asserted that he conceived of the universe as a four-buttock continuum!

This book is a compilation of vintage snapshots taken by unknown photographers. Having as their subjects family members, neighbors, teammates, coworkers, and lodge brothers, these "found photos" bring to life a vernacular world of genre scenes—a wife vacuuming a floor; someone working in a garden; a diapered baby bouncing on a bed.

The images collected here are not fancy, formal photographs but largely extemporaneous creations snapped by anonymous amateurs and developed at the corner drugstore. Spanning the first several decades of the twentieth century, the content of these frozen moments reflects a wide variety of activities and situations, both commonplace and extraordinary, while the ever sly and surreptitious camera is as likely to betray shamelessly ham-fisted mugging and grandstanding as it is to catch subjects with their pants down.

In ways perhaps only a social anthropologist can fully fathom, the pictures contained in this book emblematize their respective periods, locales, and the social milieus in which they are set. In this respect, they serve as intriguingly accurate cultural indicators, telling every bit as much about their subjects, makers, attitudes, and physical habitats as do such artifacts as automobiles, kitchen appliances, clothes, and hairstyles. Some of the photos contained herein capture moments of candid spontaneity. Others are painstakingly staged. Some represent photoplay in the literal sense, exemplifying a sort of shutterbug slapstick. Others are as solemnly contrived as the *Mona Lisa*'s smile. All seem to lend credence to Freud's assertion that, in a sort of perverse narcissism or reverse mimicry, the rump substitutes in some strange fashion for the human face.

Smooth and round as the primeval forbidden fruit, the human hindquarters comprise an organic form whose lobed architecture and curvaceous symmetry have inspired admiration since time immemorial. The photos adorning the following pages, whether seen as peep show, sustained visual gag, or sociohistorical tract, have no object other than to serve as a humble tribute to the glories of the mighty gluteus maximus and to offer a nostalgic and respectful salute to the quietly compelling majesty of a small but uniquely memorable selection of bygone behinds.

– The authors

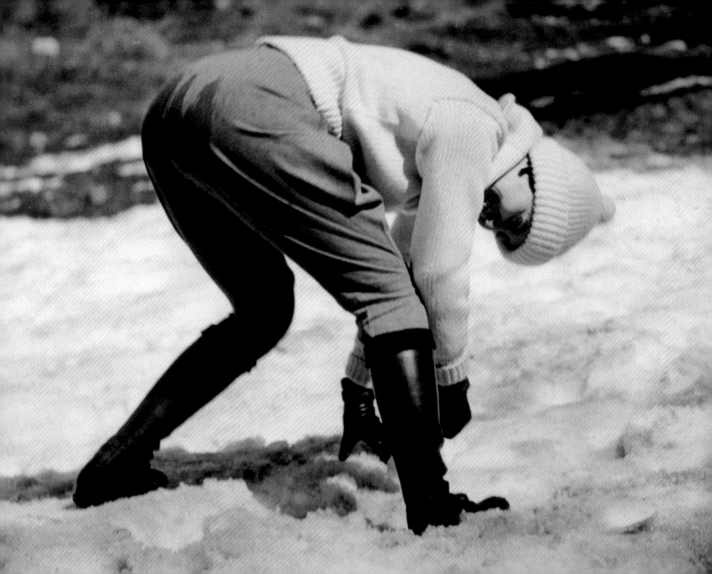

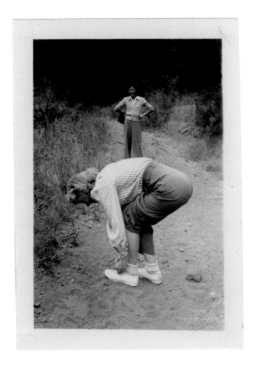

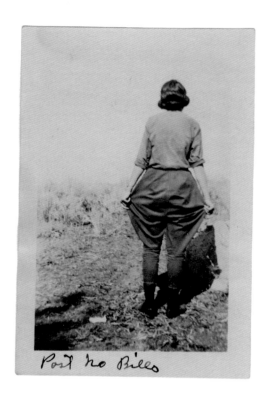

Post No Bills

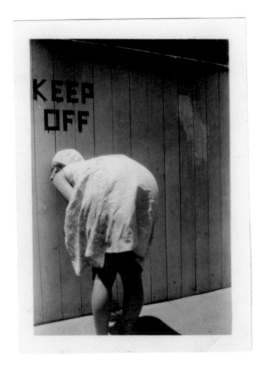

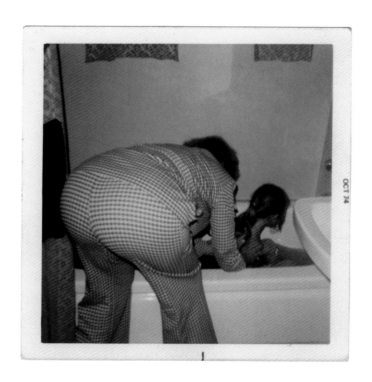

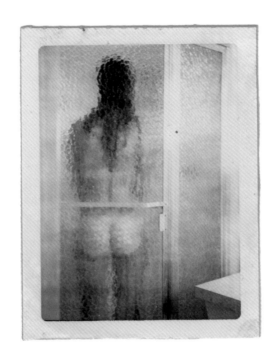

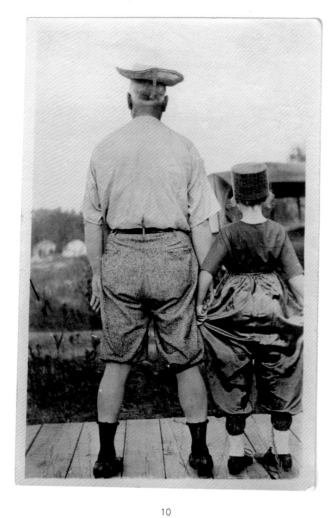

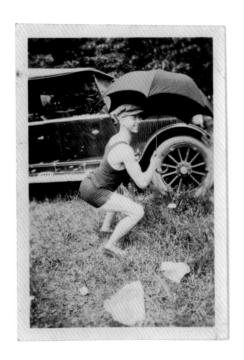

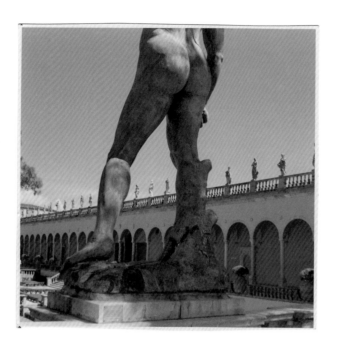

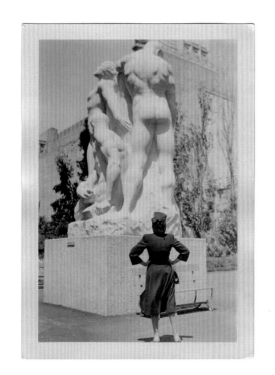

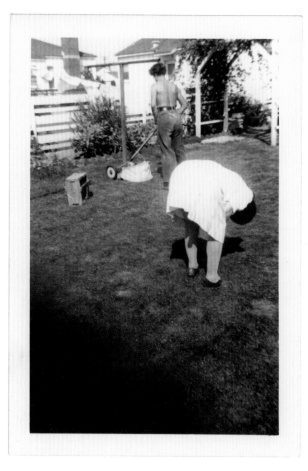

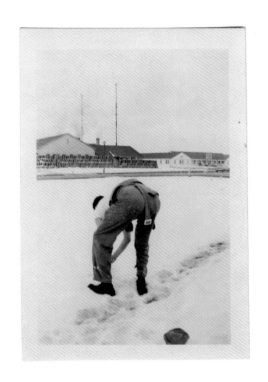

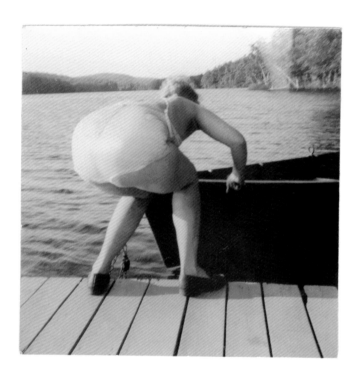

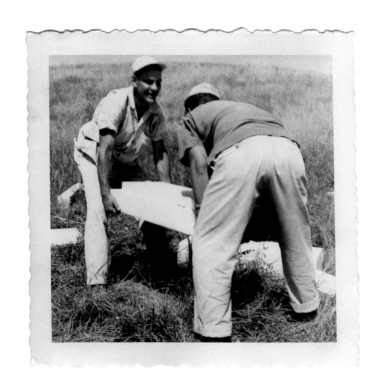

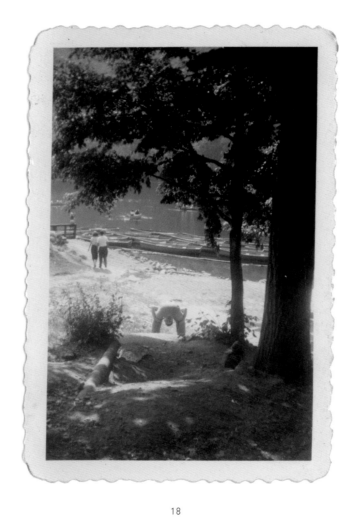

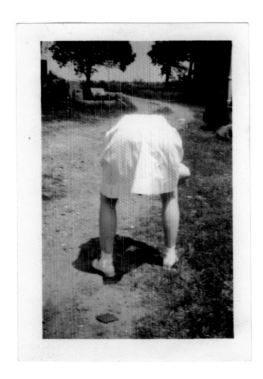

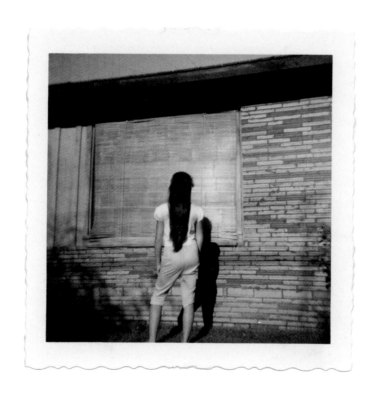

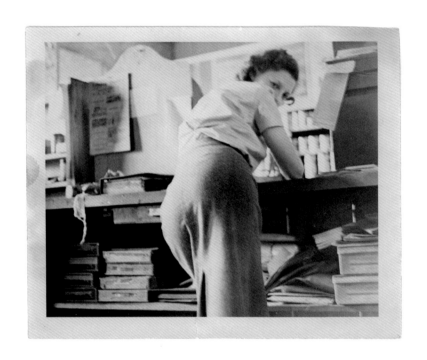

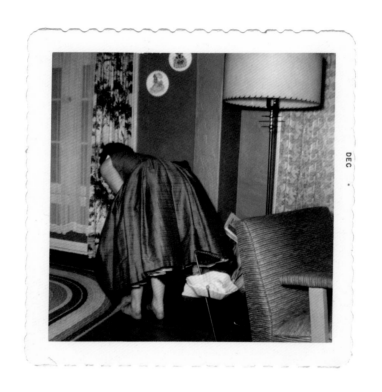

DEC

22

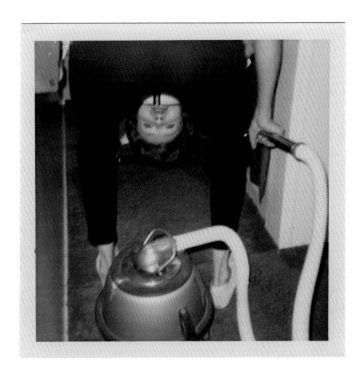

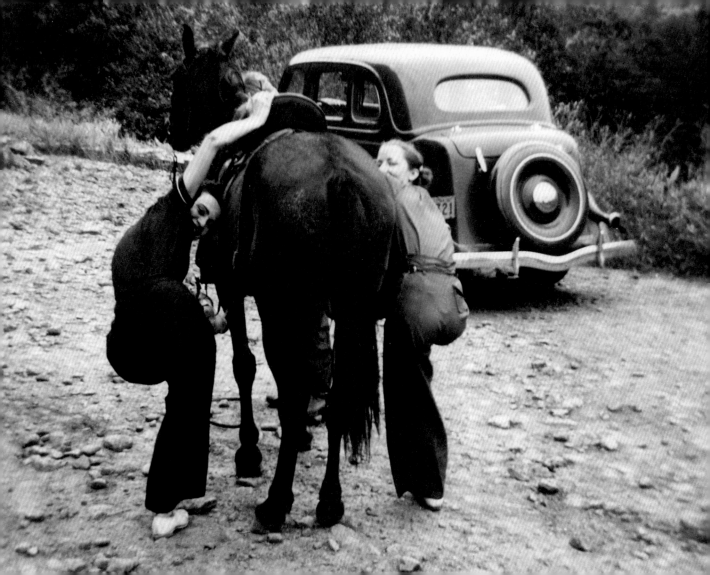

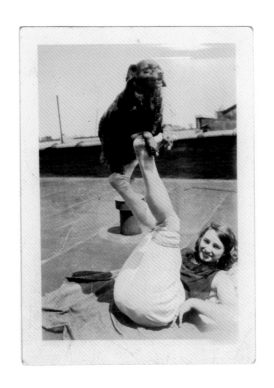

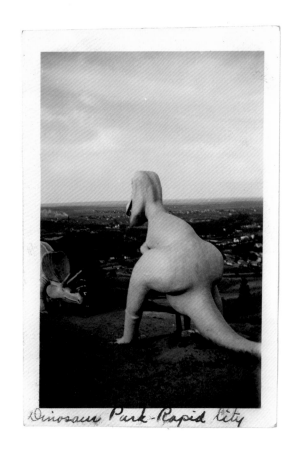

Dinosaur Park—Rapid City

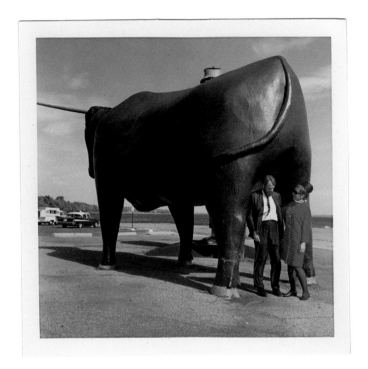

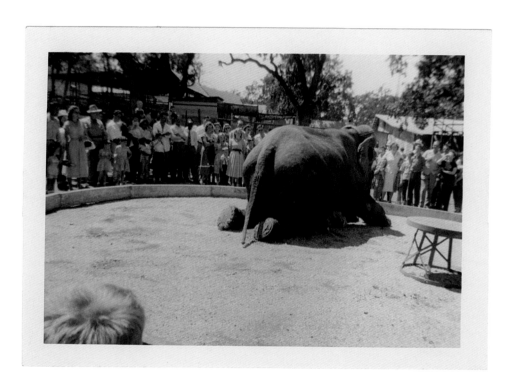

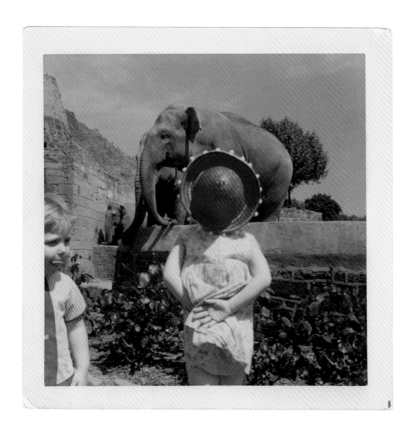

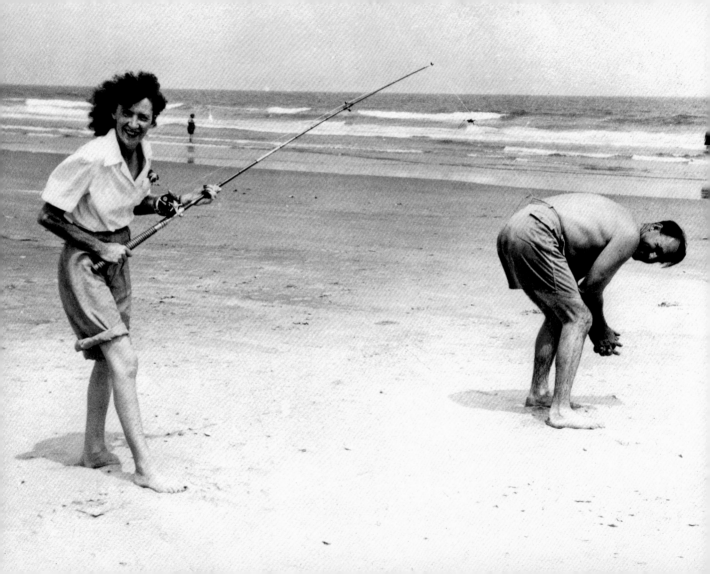

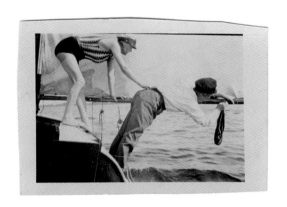

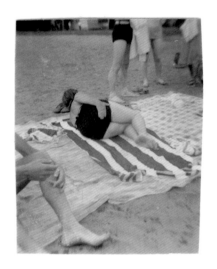

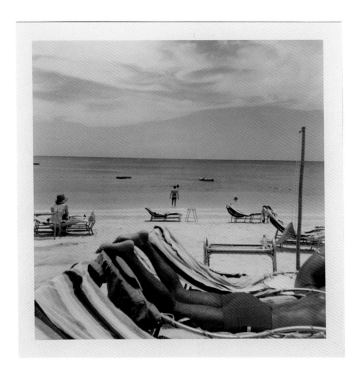

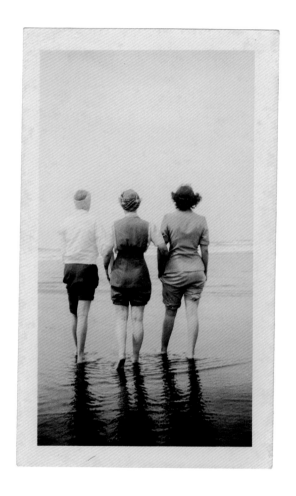

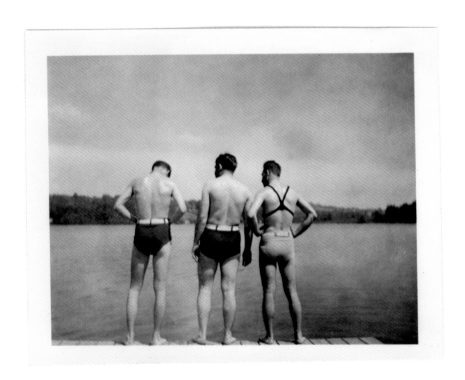

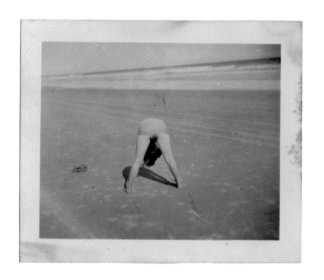

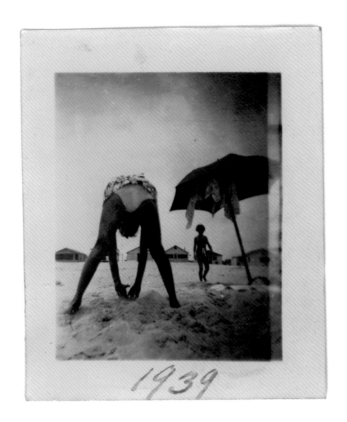

1939

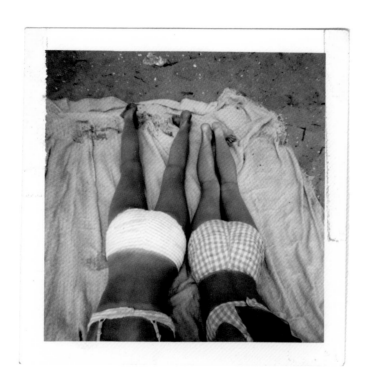

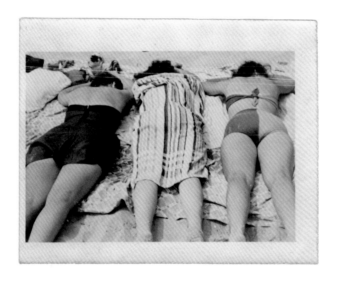

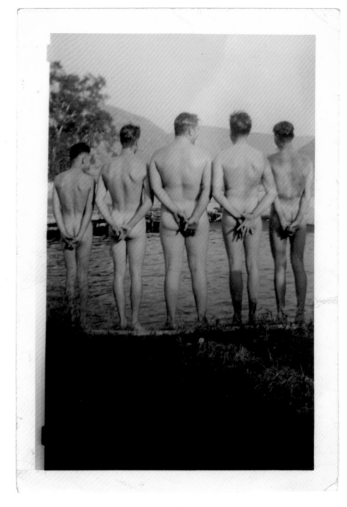

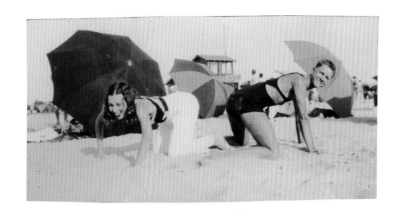

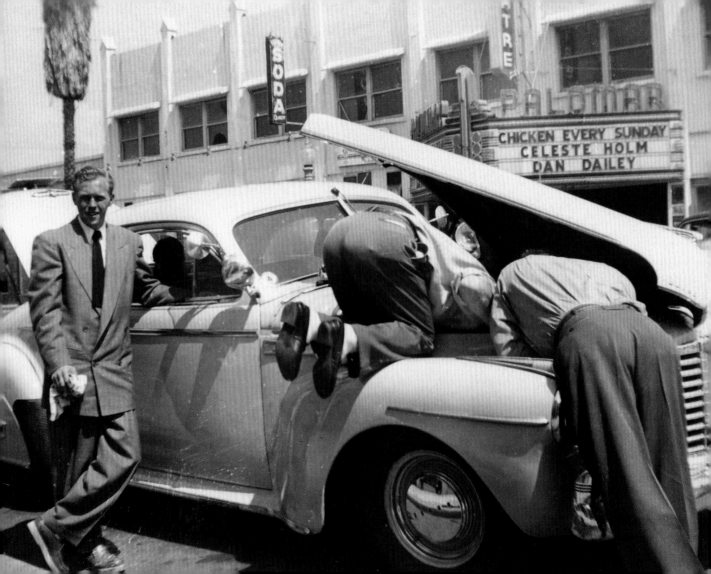

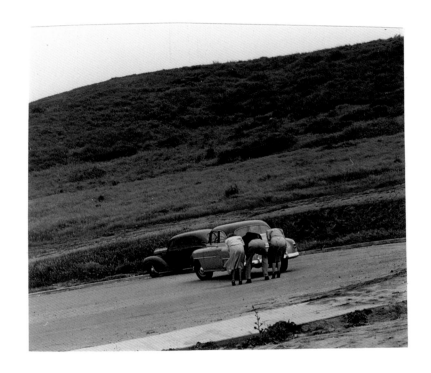

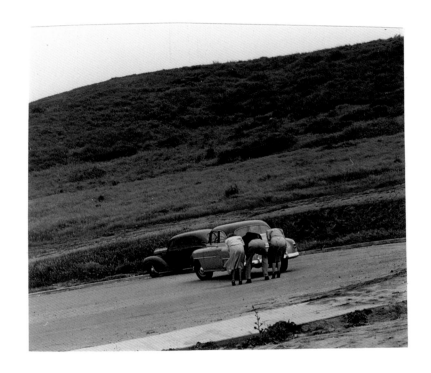

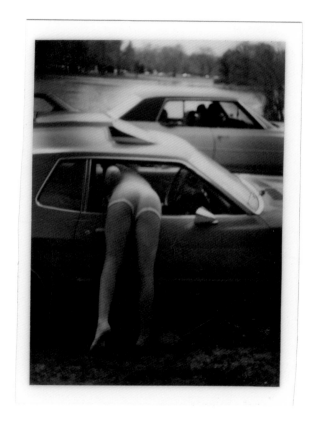

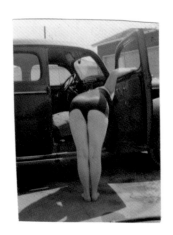

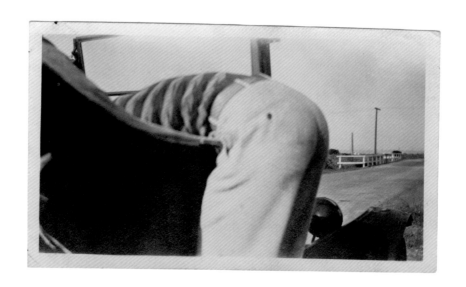

46

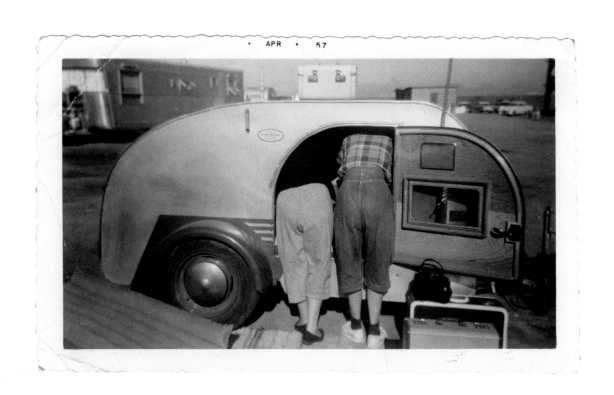

APR • 57

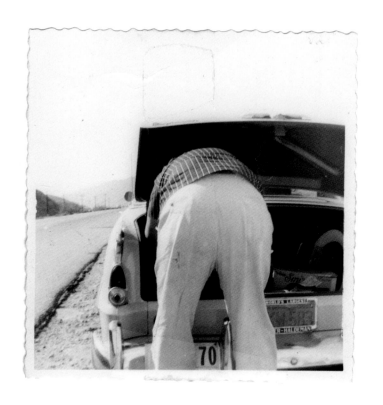

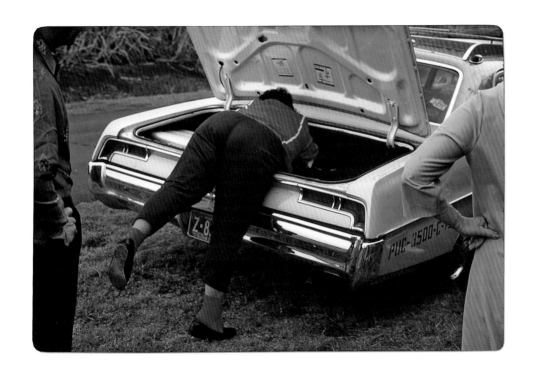

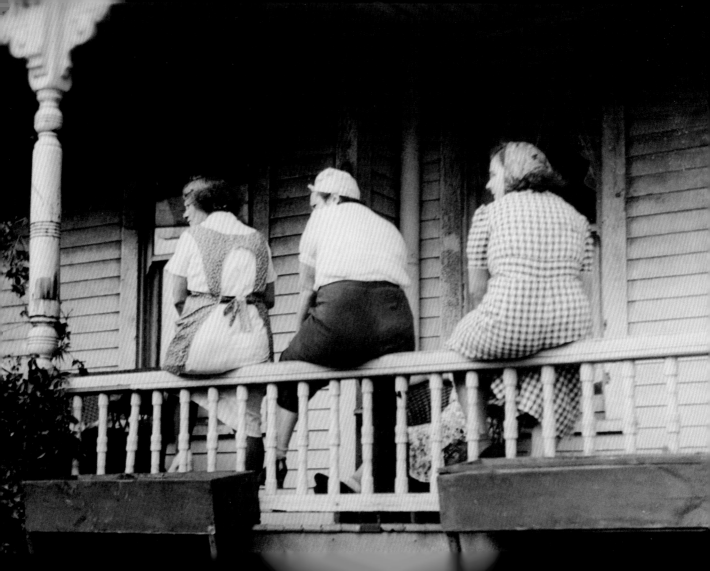

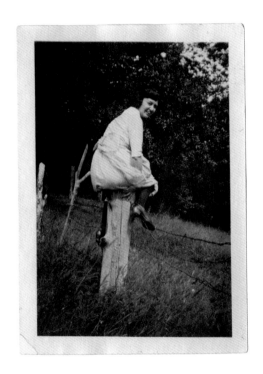

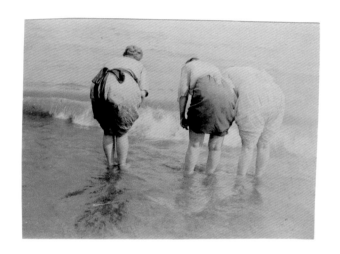

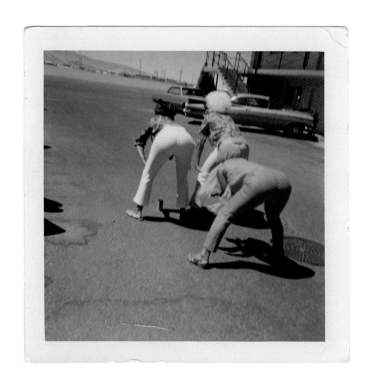

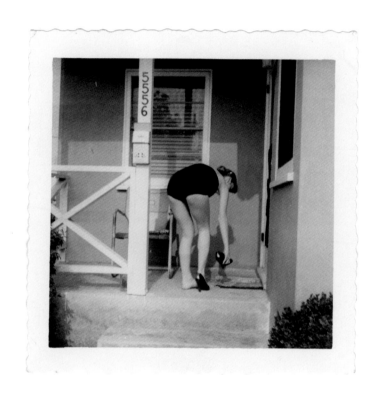

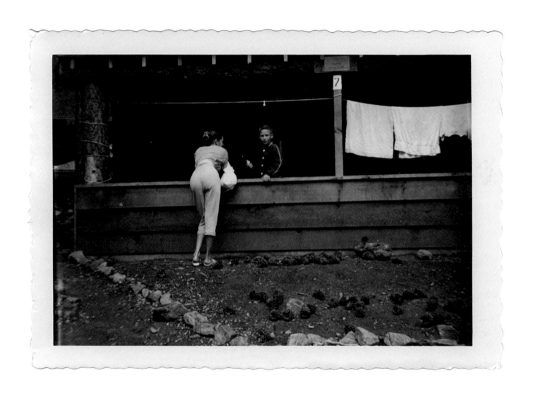

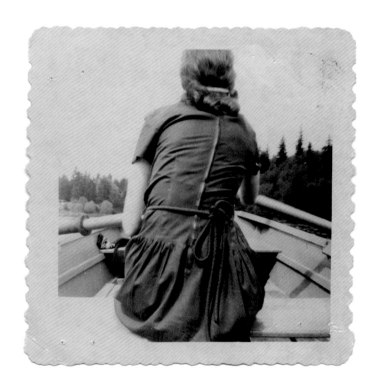

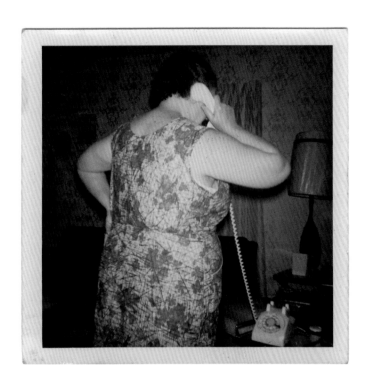

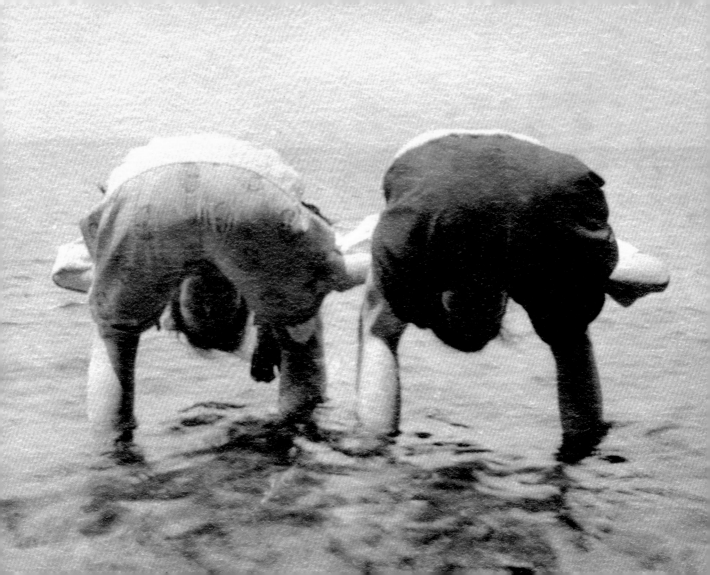

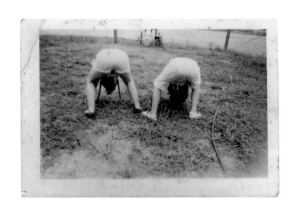

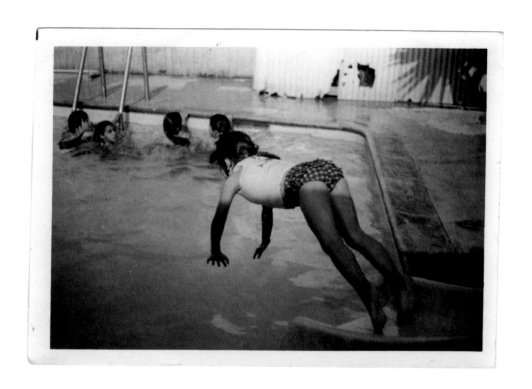

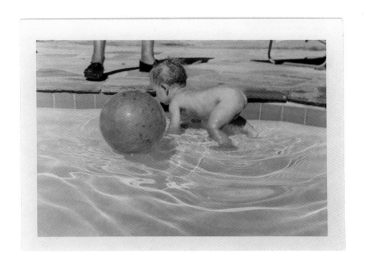

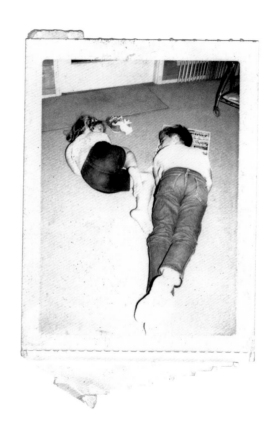

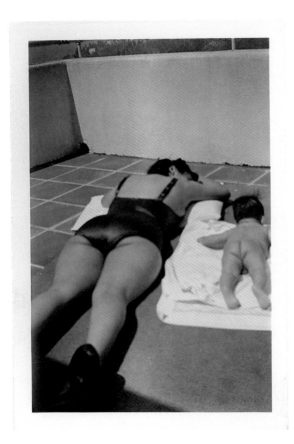

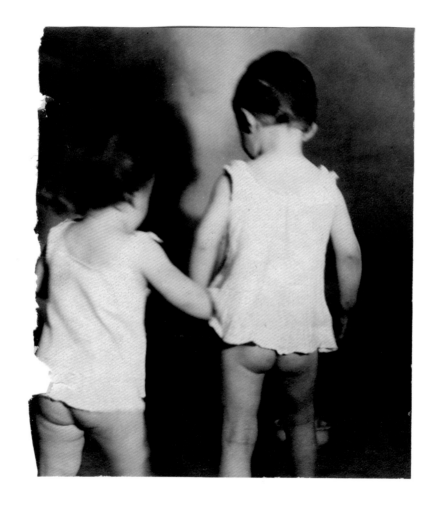

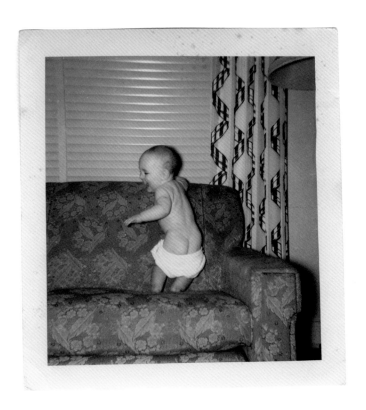

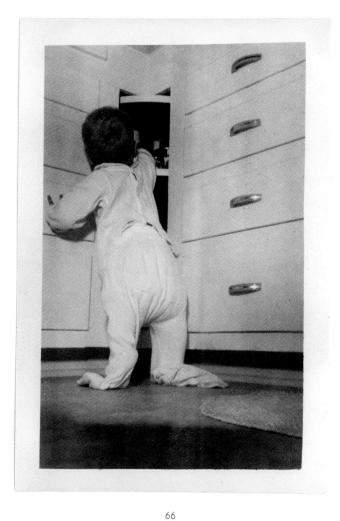

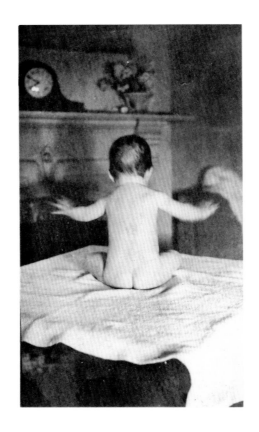

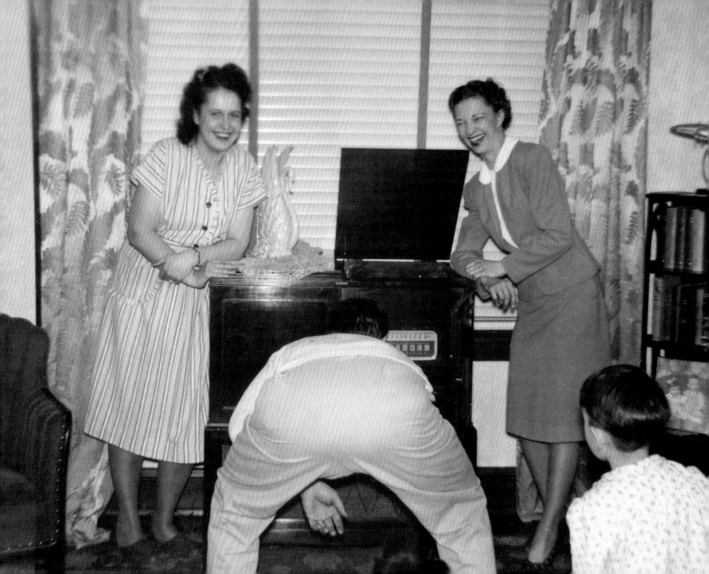

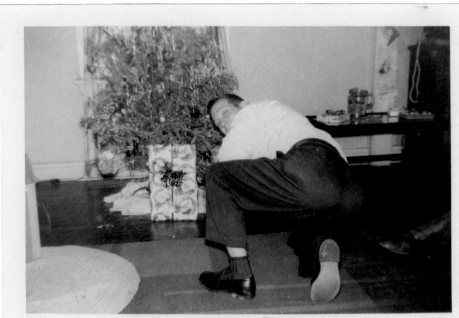

A good rear view of Charlie Myers

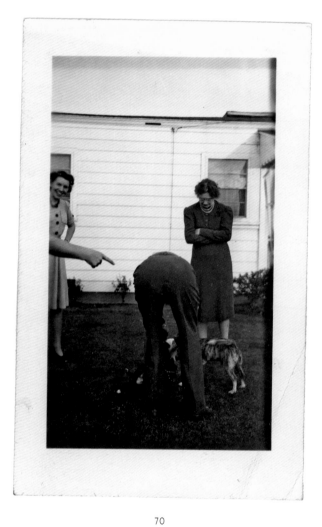

70

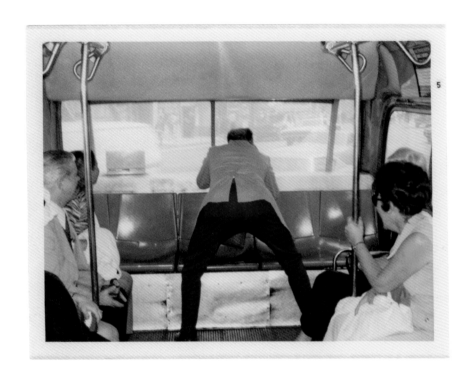

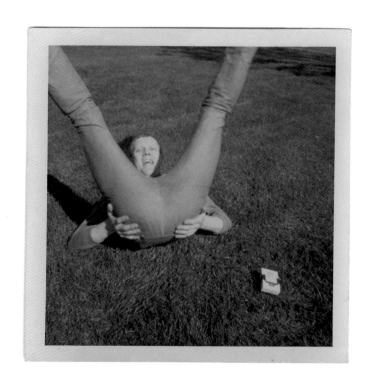

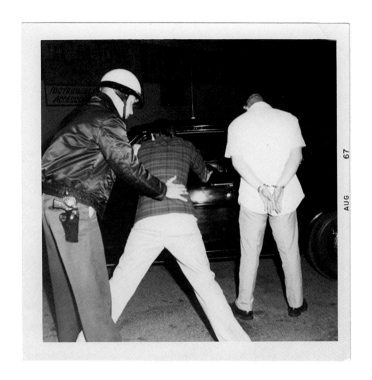

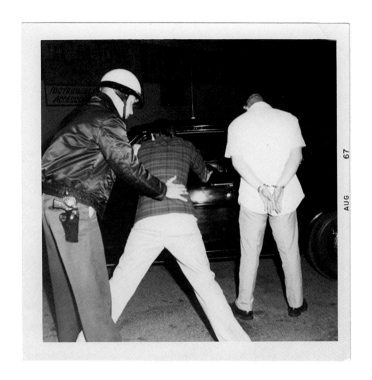

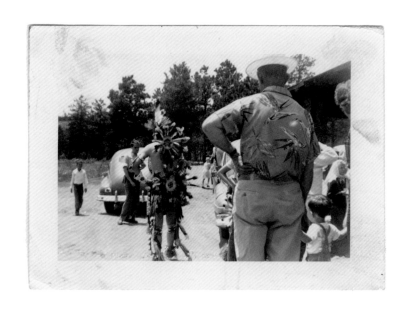

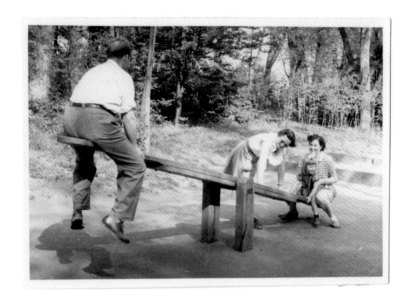

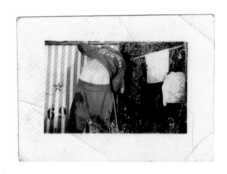

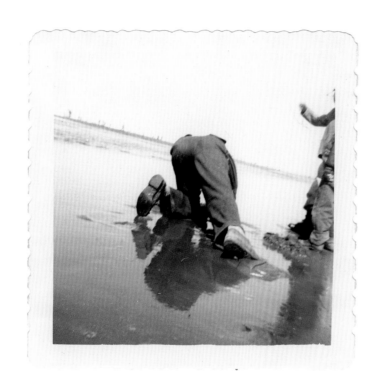

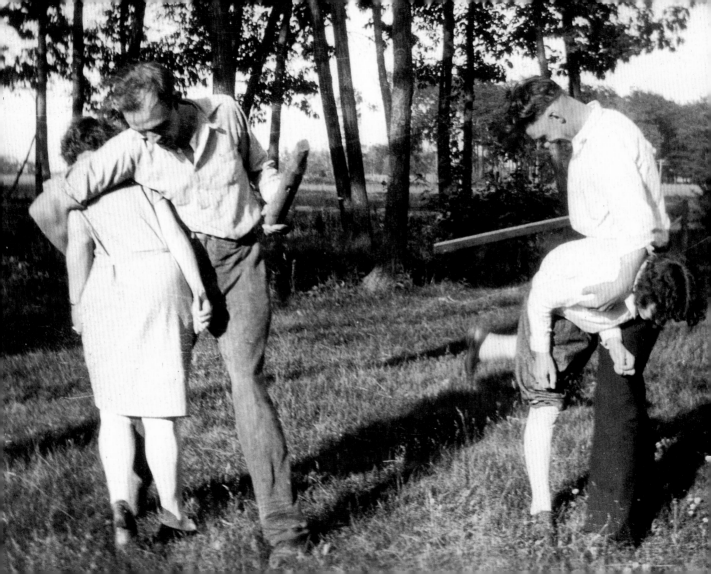

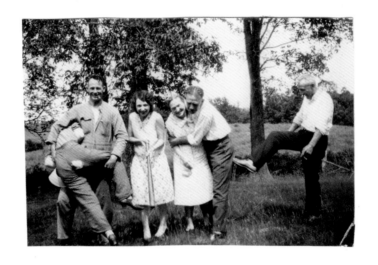

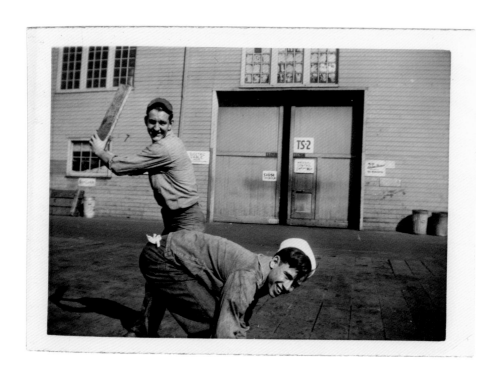

80

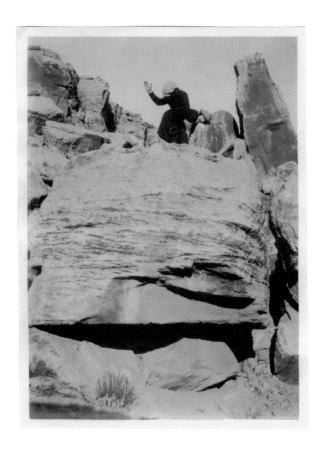

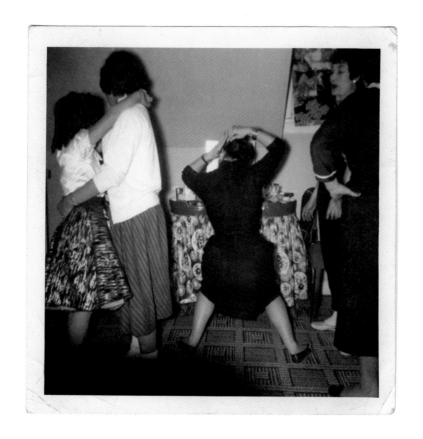

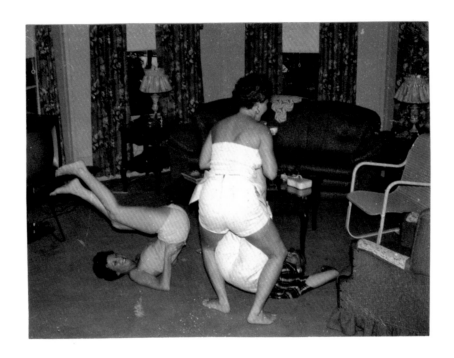

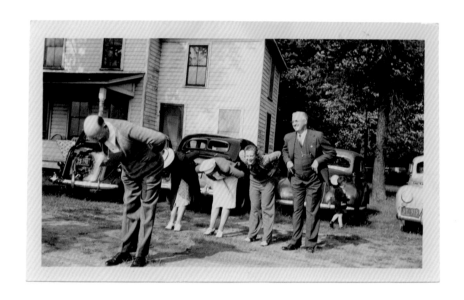

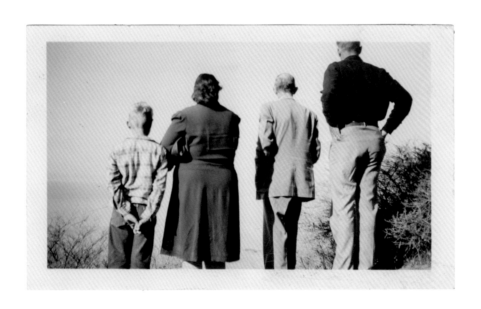

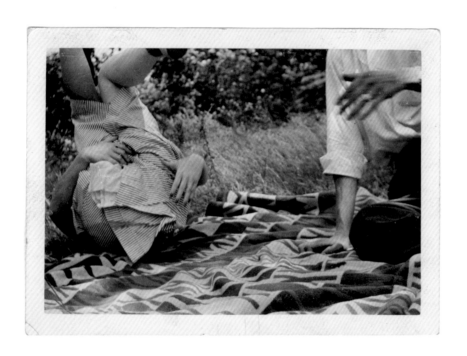

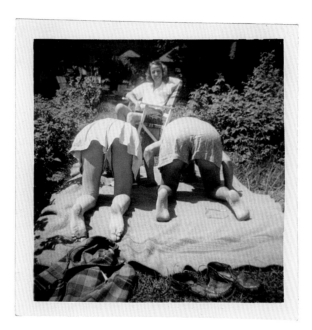

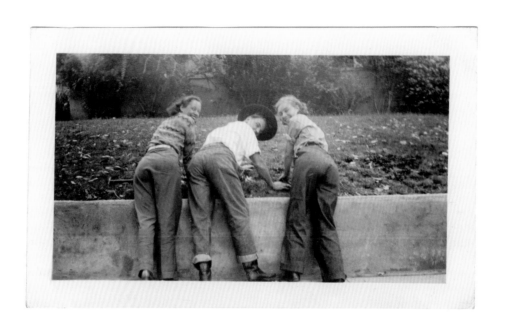

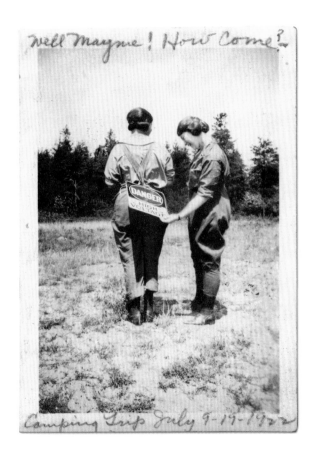

Well Mayme! How come?

Camping Trip July 9-19-19__

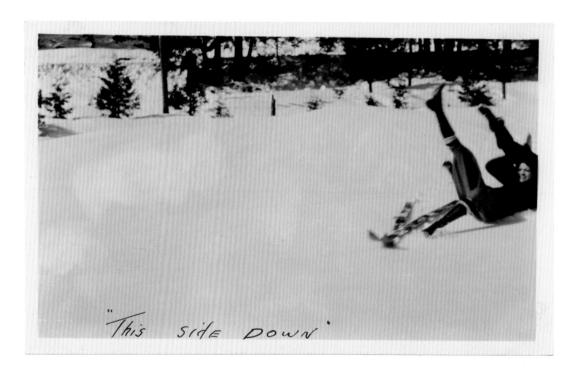

"This side down"

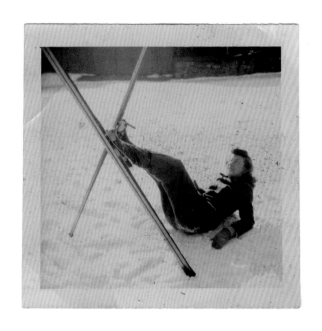

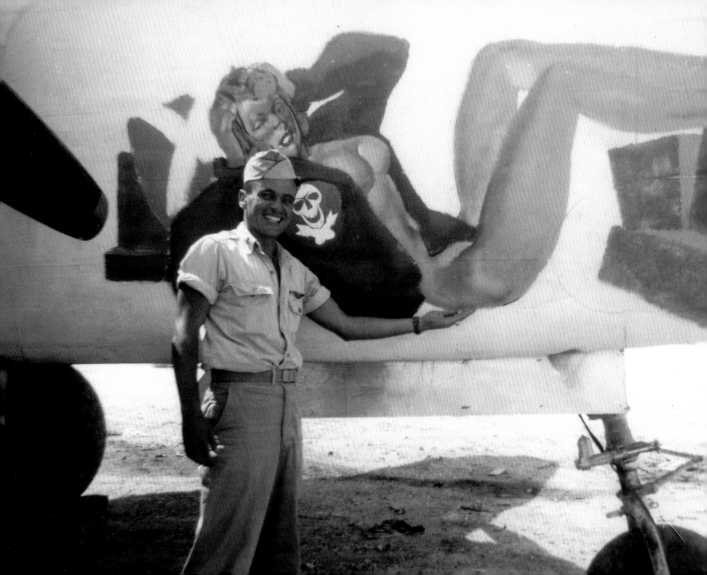

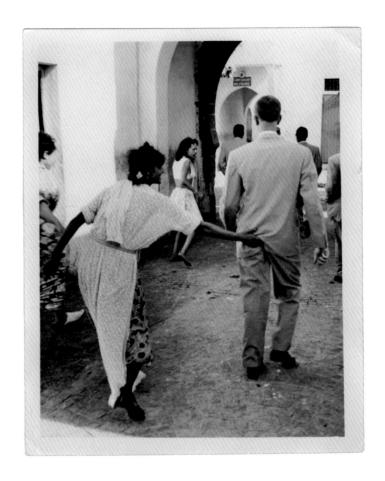

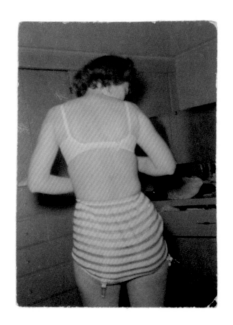

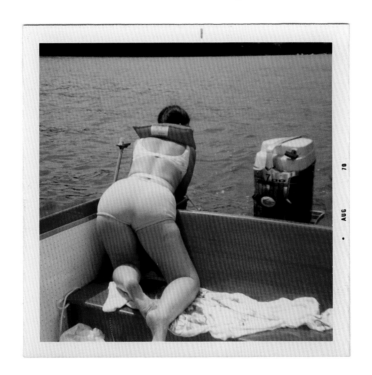

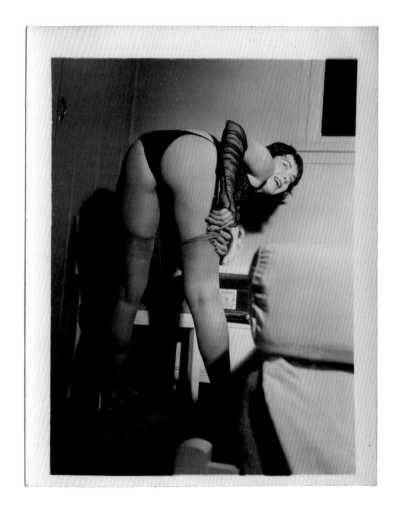

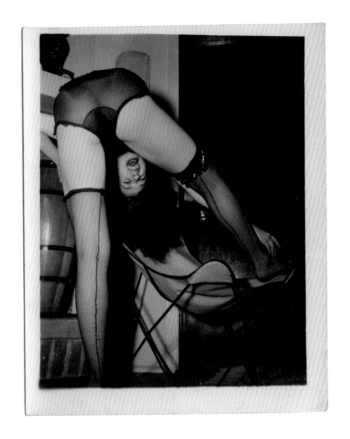

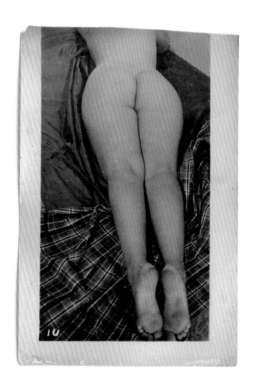

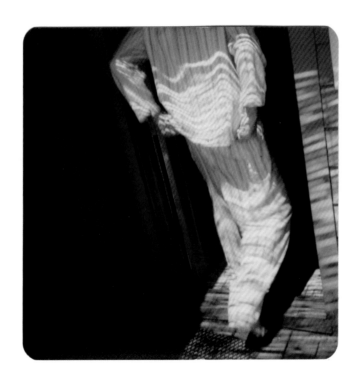

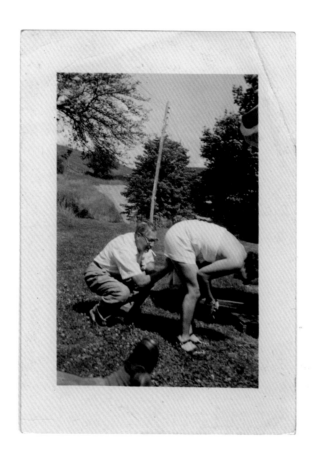

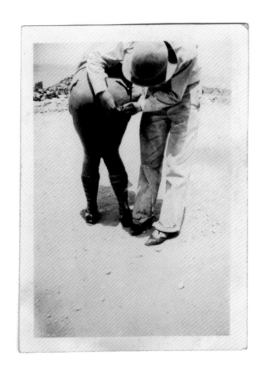

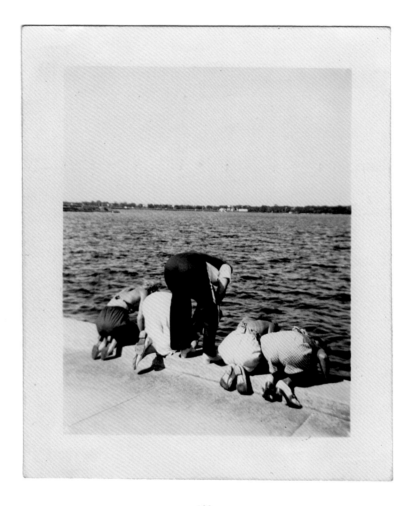

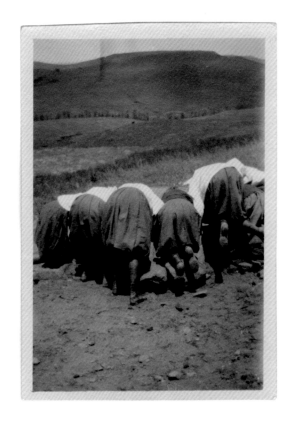

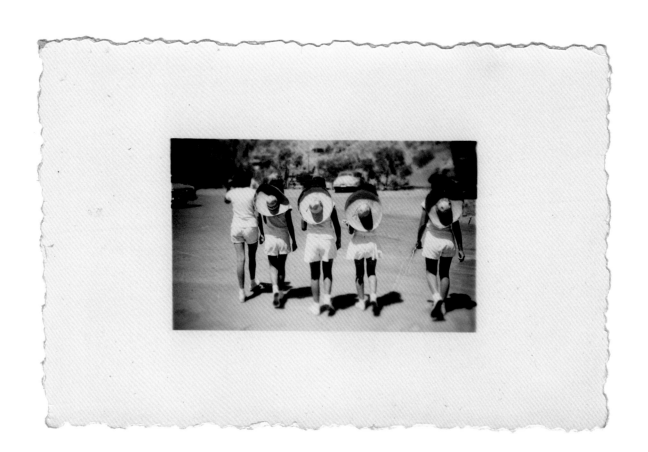

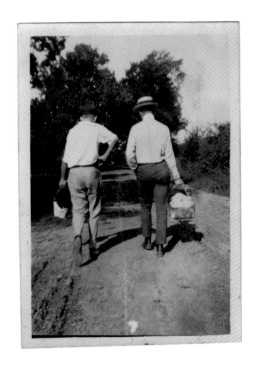

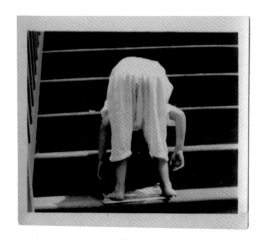

ACKNOWLEDGMENTS The authors wish to thank the following persons whose kind assistance was indispensable to the completion of this book: Andrew Seklir, Maureen Erbe, Henry Blackham, Mr. Leonard L., Mr. Ray H., Miss Sharon, Dear Jamie, Madame Babbette, Mr. Bruce Richardson Gilbert and anyone who's ever taken a snapshot.

ROGER HANDY is an artist and conceptualist whose previous publications include *Made in Japan: Transistor Radios of the 1950s and 1960s.*

KARIN ELSENER is a Swiss-American graphic designer, mother of two, and self-described thrift store addict living in Los Angeles.

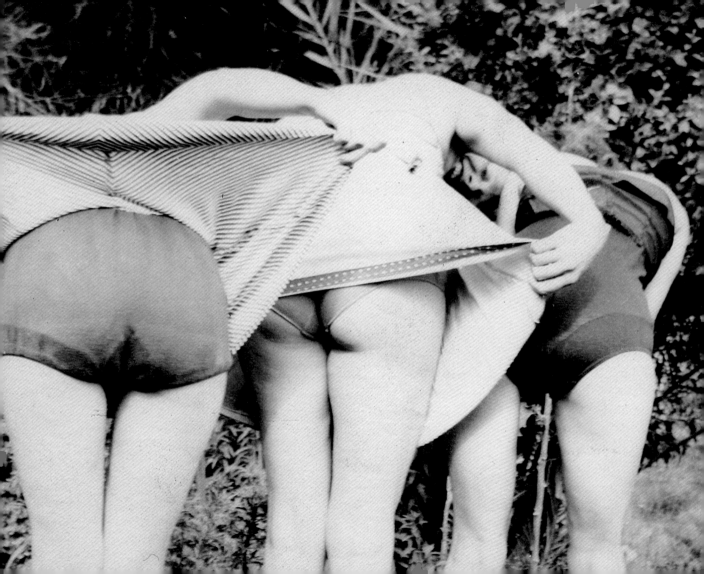

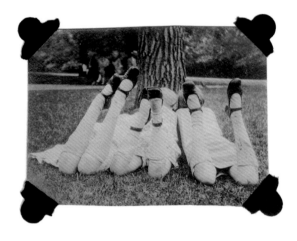

Designer: Karin Elsener

Library of Congress Cataloging-in-Publication Data:

Rear ends : found photos from the collection of Roger Handy /
edited by Roger Handy & Karin Elsener.
 p. cm.
ISBN 13: 978-0-8109-0926-7
ISBN 10: 0-8109-0926-X
1. Photography, Artistic. 2. Buttocks—Pictorial works.
I. Handy, Roger. II. Elsener, Karin.

TR653.R43 2007
779—dc22

 2006022602

Printed and bound in China
10 9 8 7 6 5 4 3 2 1

HNA ▐▐▐▐▐
harry n. abrams, inc.
a subsidiary of La Martinière Groupe

115 West 18th Street
New York, NY 10011
www.hnabooks.com